Hervé Guibert

THE ONLY FACE

Magic Hour Press
2025

In writing, I have no brakes, no scruples, because I'm the only one, essentially, who's at play (the others are relegated, as abstractions, to initials), whereas in photography, there are other people's bodies, parents, friends, and I'm always a little apprehensive: aren't I betraying them by turning them into visual objects in this way? That question, fortunately, is quickly dispelled by a second notion: that by revealing familiar bodies, beloved bodies, to strangers, bystanders who could quite possibly be indifferent (I can also imagine them being complicit), I'm doing only one thing—and it's an enormous thing, I think, which is, in the end, the purpose of all my work, of all of my creative pretensions—to bear witness to my love.

I think that in my case, photography-wise, what's interesting is my resistance to photography, the fractious, careful, suspicious way that I practice it. I take relatively few photographs, like an amateur, I only take my camera with me when I'm going on a trip. The photos that you'll see, then, were taken in Italy, Spain, Poland, Czechoslovakia, the United States, and yet those countries are unrecognizable in all of them, they could have been taken in the suburbs of Paris, or anywhere. And yet they are different, I imagine, for the sense of a country, the exhilarating fatigue of travel, its perceptive acuity, reverberates within them. Beloved bodies are available to me everywhere, including the suburbs of Paris, but it's only when I'm far away, in contrast, alone with myself in a foreign land, that I want to photograph them; freed from habit, lost in incomprehensible consonance, they become characters in a travel diary.

I'd like to share an anecdote, because I think it speaks to my position, or my aspiration, in photography, relative to a parameter, a kind of benchmark of indisputability, that is Cartier-Bresson. Recently, I went to Prague with him and several others to see a photography exhibit curated by his friend, Anna Farova. The exhibit was in the country, 100 kilometers from Prague, in an ancient monastery built on stilts above

a swamp. That exhibit was such an event for the residents who attended it, such a symbol of freedom, such a gesture against harassment and towards awareness, that it seemed as if a field of emotion were suspended in the air, a low-volatility vapor that unified everyone. Anna Farova made a speech, then the mass of people surrounding her rushed into a small, round chapel, lit in the vault by a small skylight that let the light flow in very softly, to hear the music that was about to be played. Cartier-Bresson and I were the last to enter, and found ourselves pressed up against each other, at the very back of the chapel, near the door, with our backs against the wall. After the sound of clicking shutters had ceased, a grave silence set in, and the slightly funereal complaint of a violin rose up. And then I forgot about Cartier-Bresson, because I realized that the entire forest of bodies packed tightly in front of me, with its back turned to me, its gaze fixed on the musician, was directing me, through the spaces created by the subtle and random play of intertwining shoulders and heads, towards a face, the only one looking in my direction, framed like a jewel in a tiny setting, exactly opposite me, flattened against the wall on the other side of the chapel like a spatial twin. I immediately fell madly in love with this face. To me it was a perfectly photographic moment: programmed by chance and spatial configuration, a photographic *coup de foudre*. If I shifted left or right a few centimeters, or if the face shifted in its own right, the vision collapsed, the face vanished. I picked up my camera, quickly set the focus to infinity, and took the photograph.

Several seconds later I felt Cartier-Bresson, who was standing to my right, stir. He kept turning towards his left, and when I turned to follow his gaze, I saw a small group of people, magnificently illuminated by a slender niche of light cutting through a high window, who disorganized, through the torque of their staggered necks straining to observe the vault of the chapel, the visual logic of the crowd gathered together to listen to the music. Cartier-Bresson stirred until his vision stabilized, refined, balanced itself, then he very abruptly removed his lens cap and furtively, in two or three rapid movements, as I was trying with all my might to flatten myself against the wall while holding my breath so as to not disturb his sleight of hand, took the photo. Then I saw something astonishing, and for me unprecedented, in his face (which I was somewhat familiar with, as I had been able to observe it in multiple circumstances): the photo had been taken, but Cartier-Bresson turned back one last time towards the group as if to check his vision, and in his expression I saw the look of a killing, of an abandonment after the kill. None of the people in the group, obviously, interested Cartier-Bresson, only a relation of light, a geometric anomaly blazing through the human mass.

Whereas for me, and obviously I'm not comparing myself to Cartier-Bresson, the photograph was merely one moment

in my relationship to a face, a sentimental attachment. In the hours that followed, each time the group dispersed and came together again in a space other than the chapel, gallery, or refectory, I searched for the face in the crowd and the moment I spotted it I took a photograph of the space that separated me from it, of the lines of *rapprochement*, of attraction drawn by chance, in a game of dice between myself and space whose stakes were desire itself. My attachment to this face was animated entirely by the photograph, for the photograph was also a way for me to approach it (like a lion, I imagine, moving in concentric circles around its prey).

I'm going to say something very directly, perhaps almost crudely, because at the moment there's no other way to say it: my mother had cancer surgery three weeks ago, and when I saw her again for the first time, I saw a jaundiced old woman, staggering down the hallway holding a drain in her hand. The hospital light was cavernous: as my mother lay in bed, that light accentuated the hollows of her eyes, redrew a skull and crossbones where her face ought to be. Photographing her like that was out of the question; I even thought that I would never photograph her again. Because time was passing so slowly, and the conversation so thick, I came up with the idea to draw her: that could be another way to look at her, to love her, to converse with her in silence. The second day I brought a sketchbook, and pencils in my pocket, but I set the notebook down on the table next to the flowers and only picked it up again when I was leaving, I didn't even try: I was afraid that I'd be afraid of the drawing that would emerge on paper, and, since I'd have to show it to my mother, of frightening her.

Three weeks later she moved out; an ambulance brought her to a clinic in the suburbs for radiation. I went back to see her. Suddenly, in the hallway, as I steered myself towards the door that bore the number she had given me and that I already knew by heart, I saw a very vibrant ray of light. I went into the room, which was vast and luminous, slanting rays from a skylight illuminating my mother as she lay in bed. And suddenly that light reconciled me with my mother, or rather, the image of my mother, and with my hope that she would stay alive. I wanted to take her photograph. I told her she was beautiful and I believed it. For the first time, I thought she was going to live: the light on her face, the renewal of photographic allure, was its guarantee.

—Hervé Guibert

*for Agathe Gaillard*

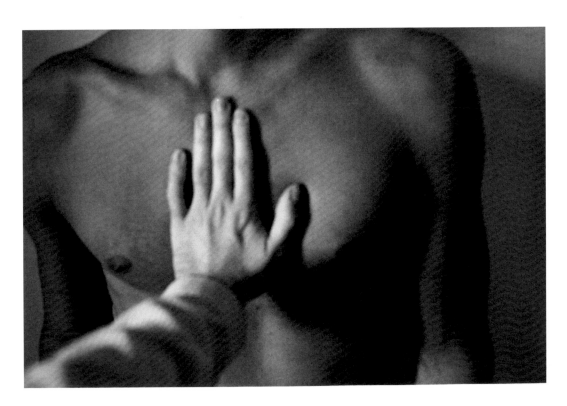

The friend

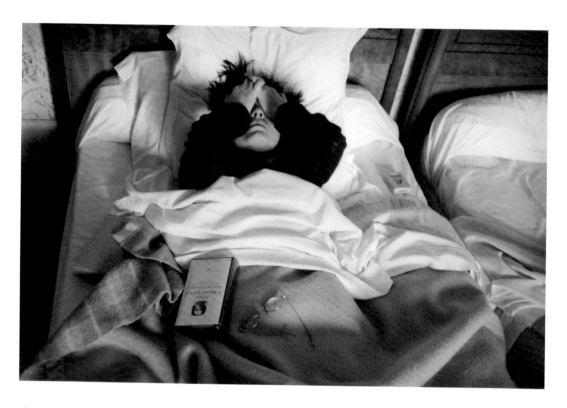

Claire

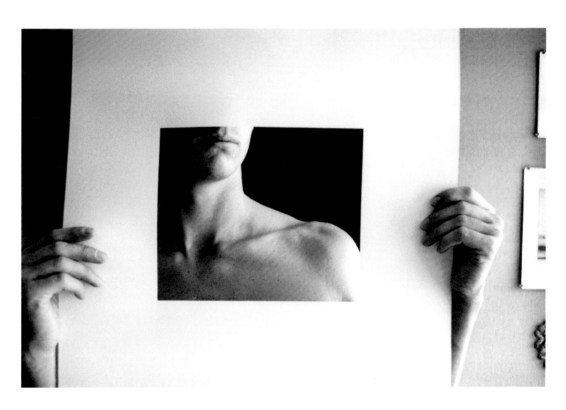

Gorka

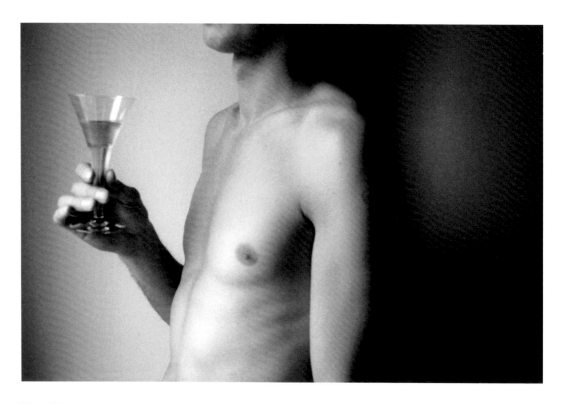

The Glass

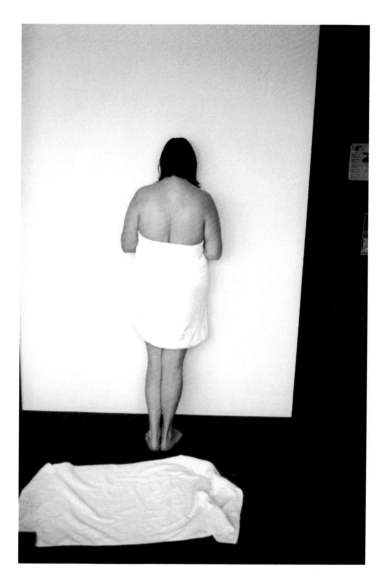

Zouzou

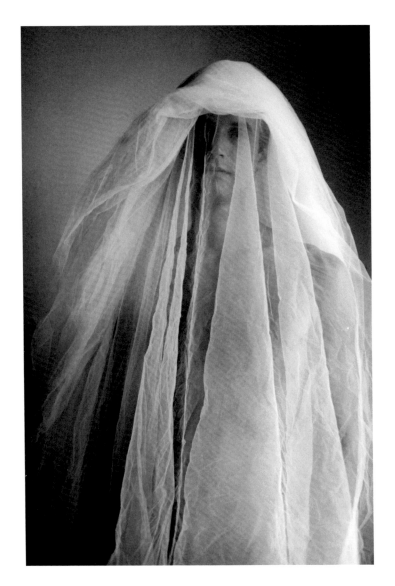

The fiancé

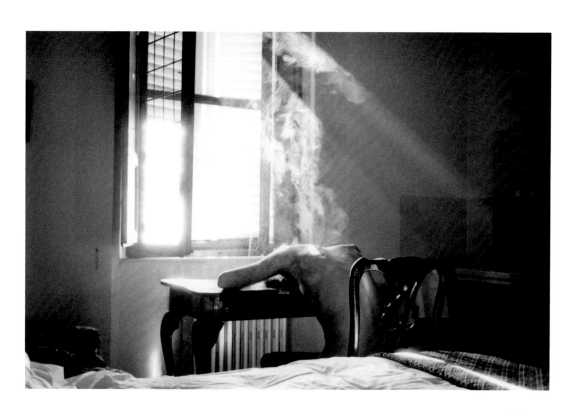

Sienna

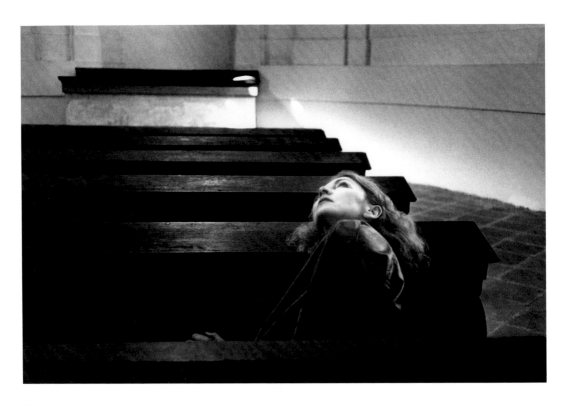

Prague

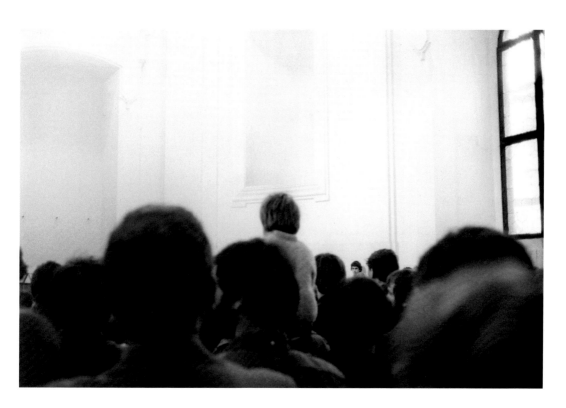

The only face

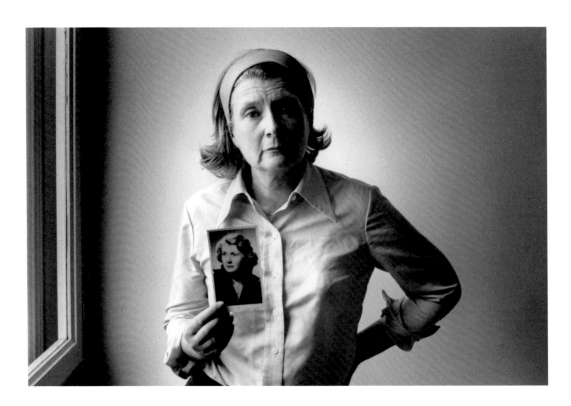

The mother

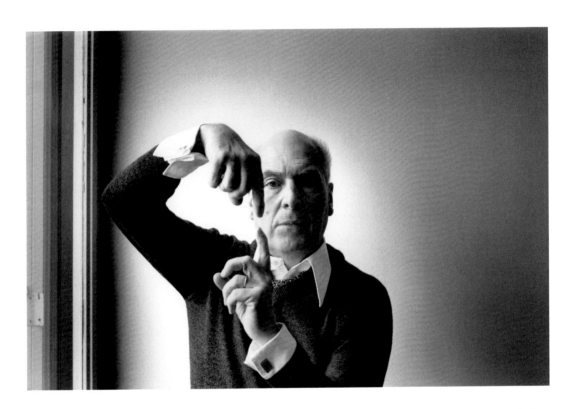

The father

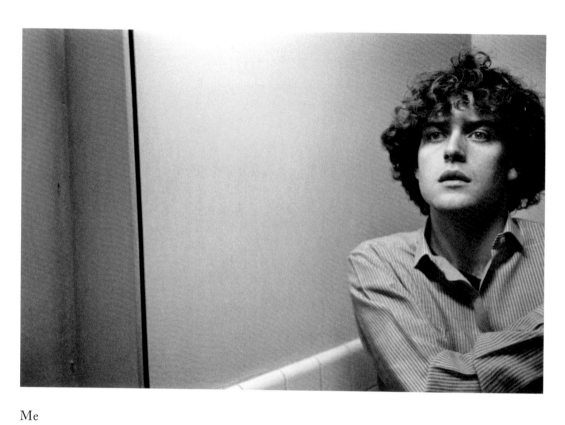

Me

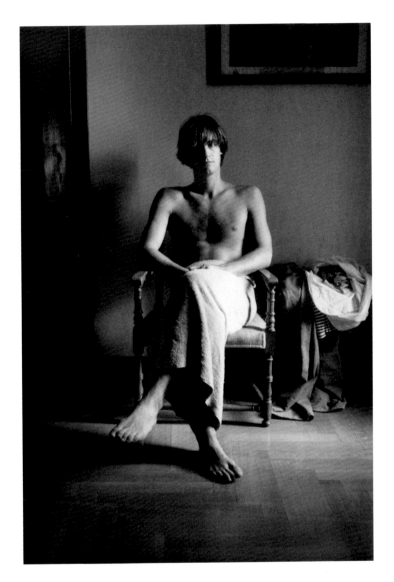

Thierry

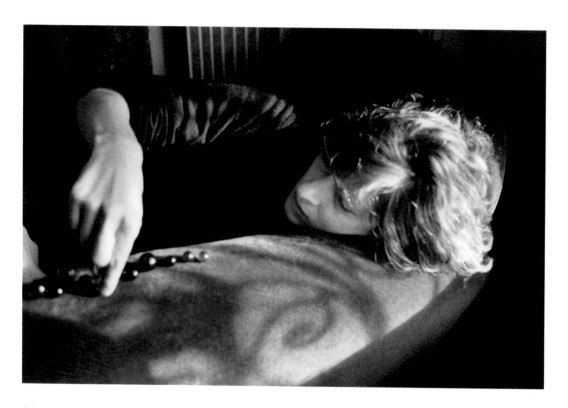

Christine

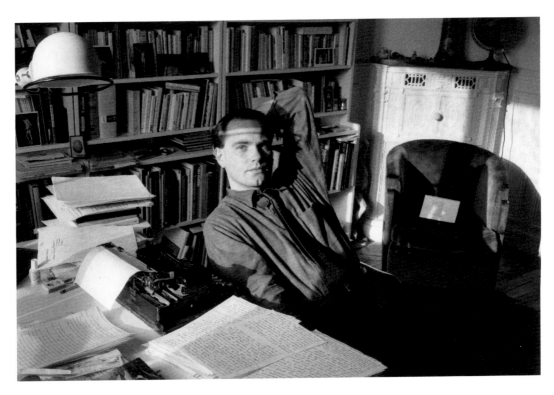

Hans-Georg

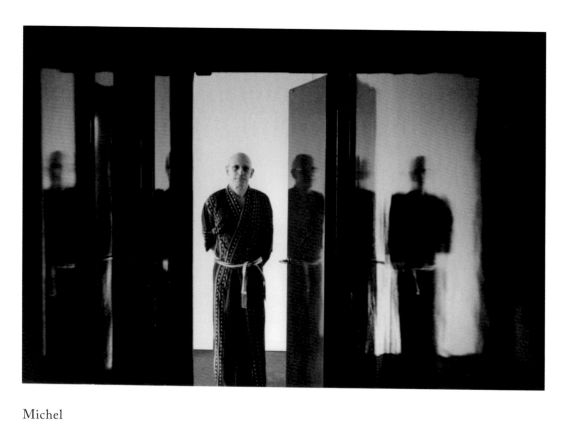

Michel

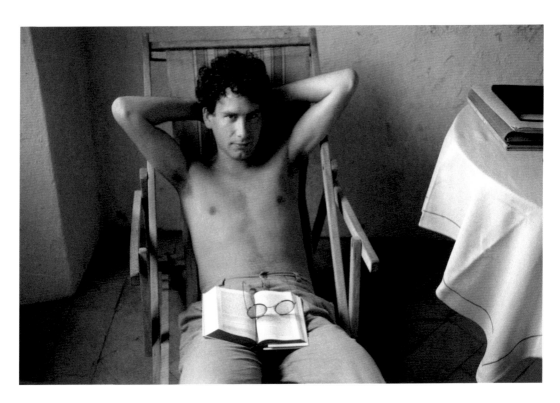

Mathieu

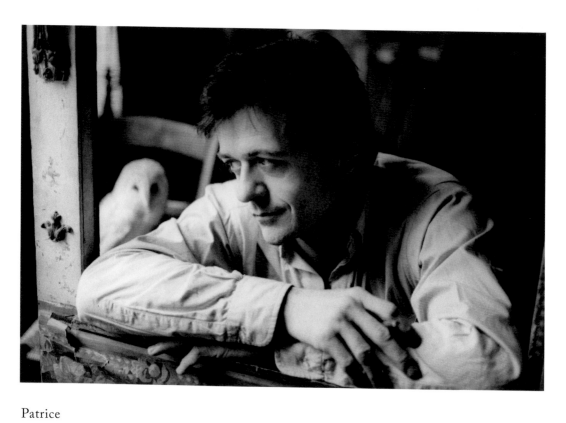

Patrice

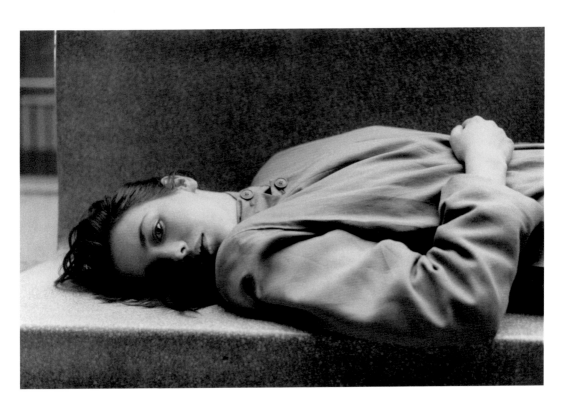

Isabelle

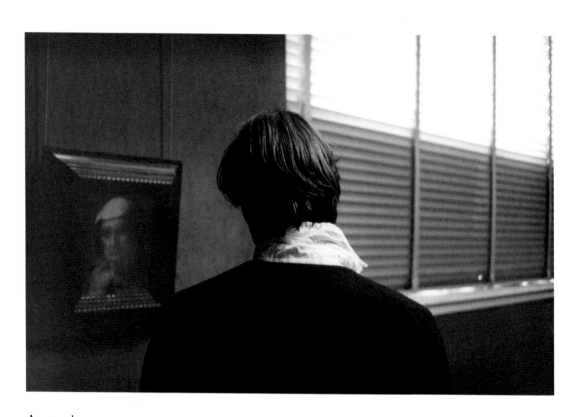

Amsterdam

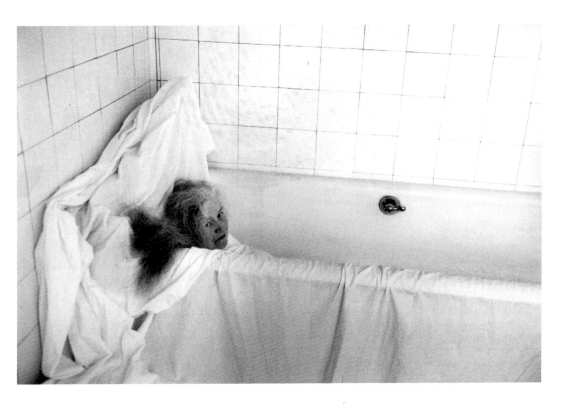

Louise

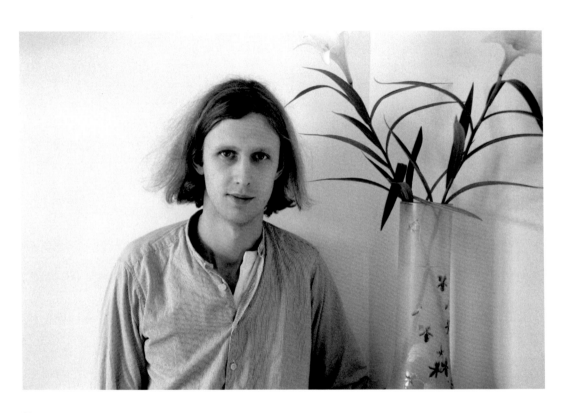

Eugene

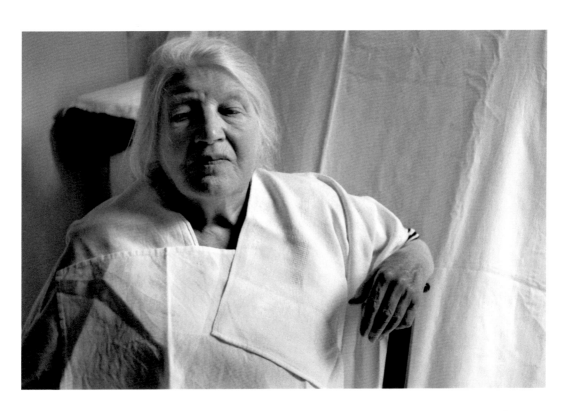

Suzanne

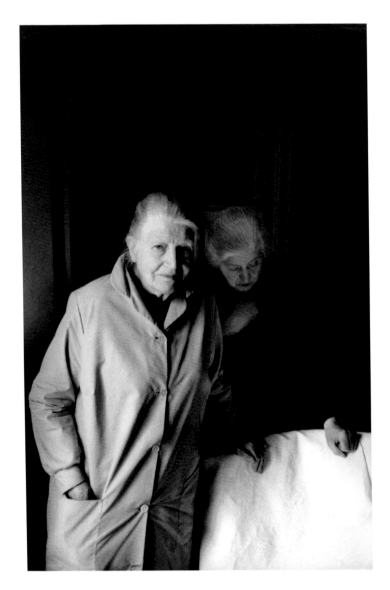
Suzanne and Louise

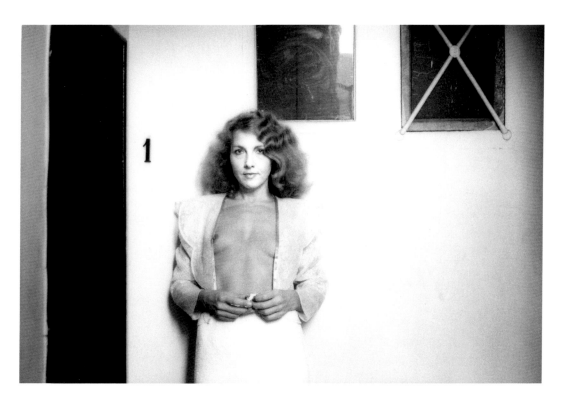

Agathe

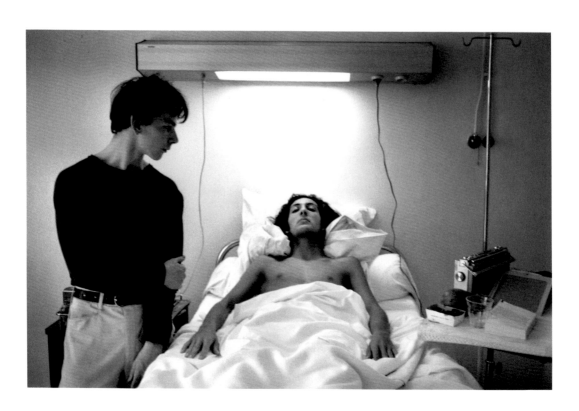

The friends

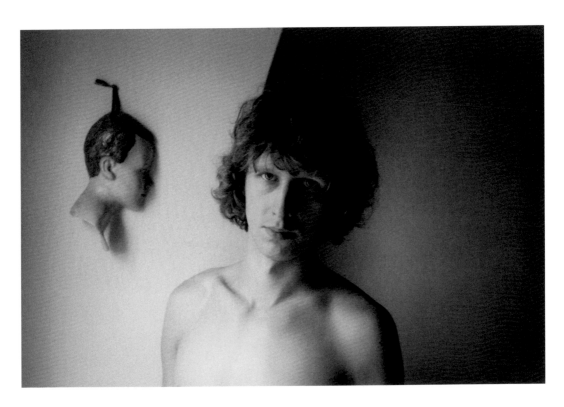

Eugene

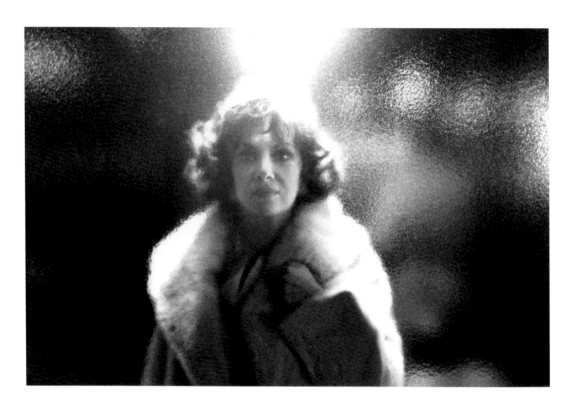

Gina

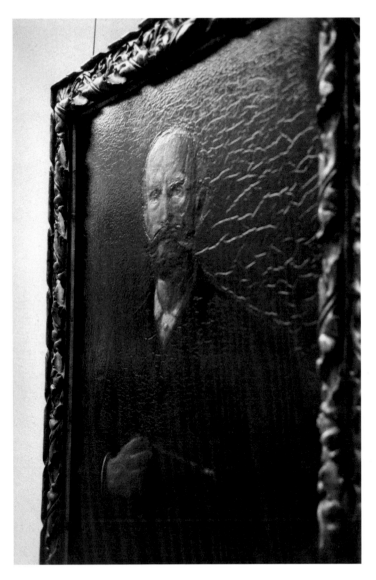

Self-portrait

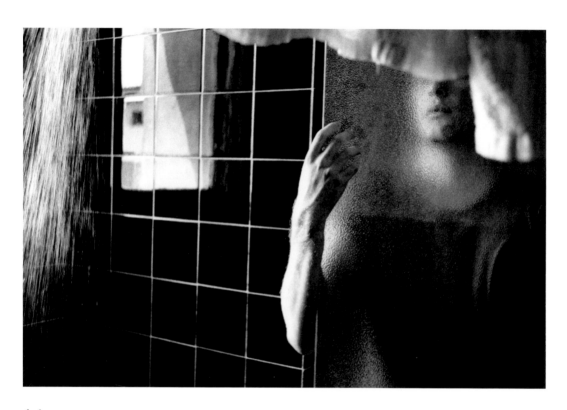

Arles

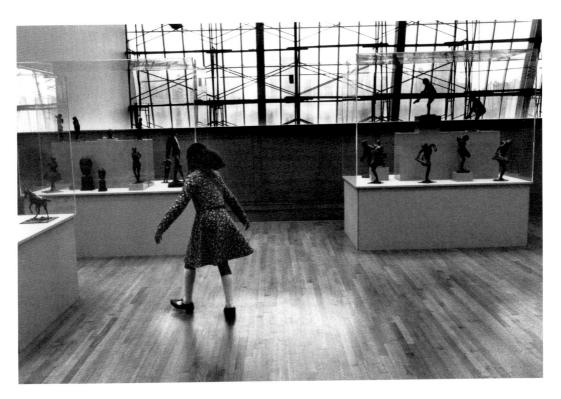

New York

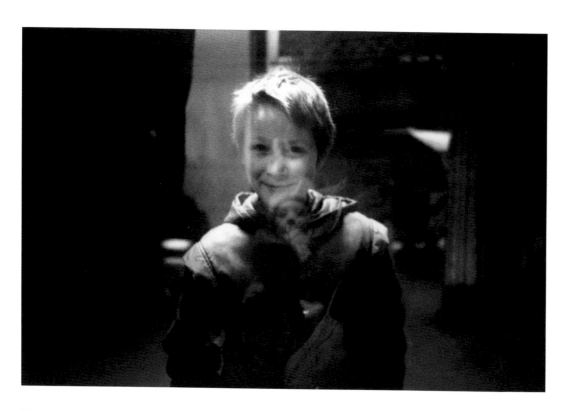

East Berlin

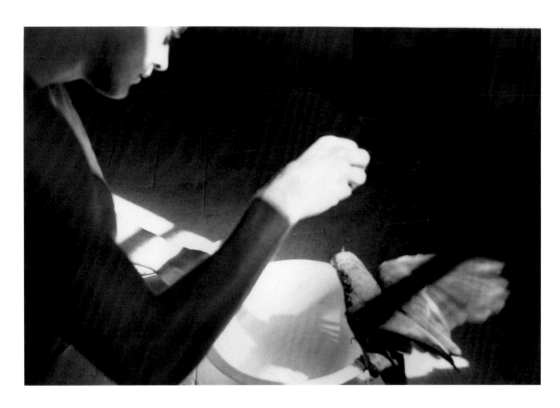

The bird

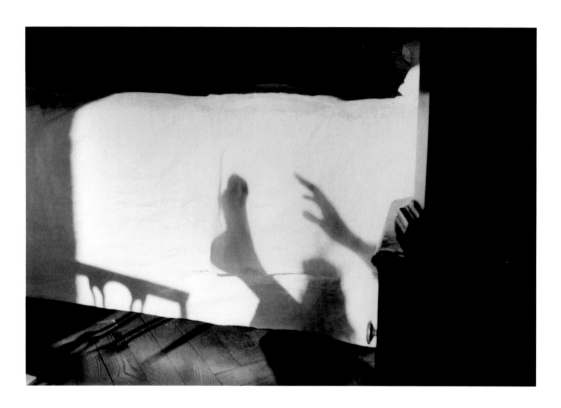

Chinese shadow

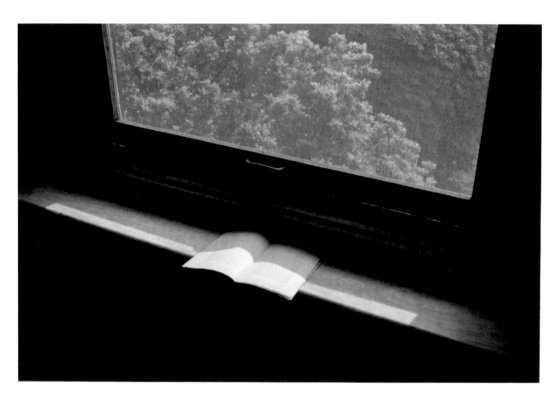

Reading

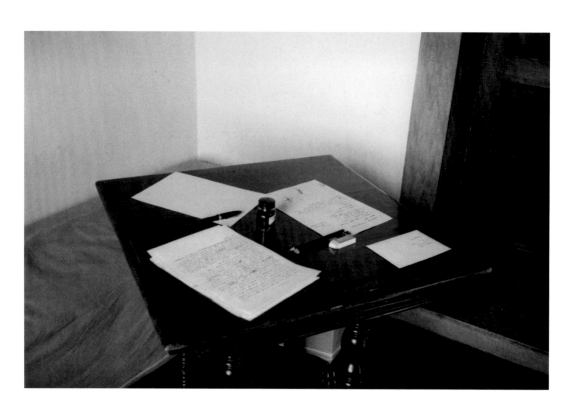

Writing

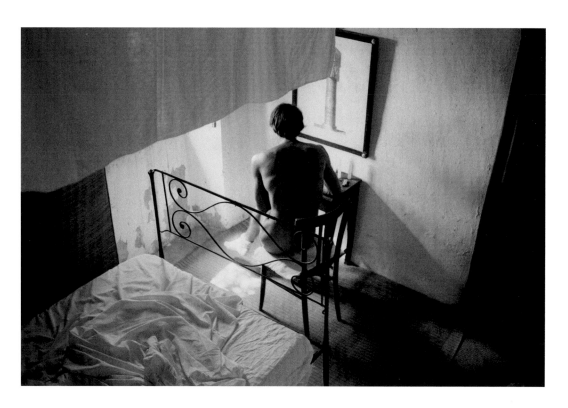

Writing

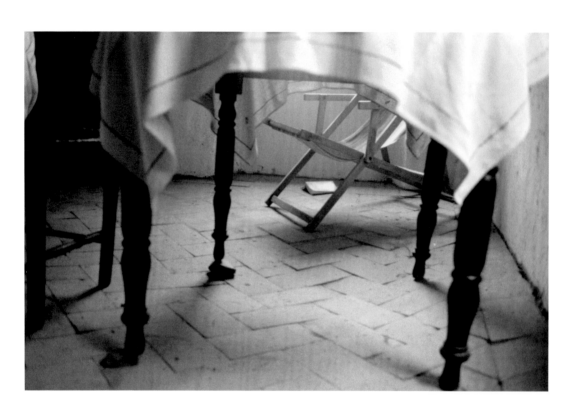

Reading

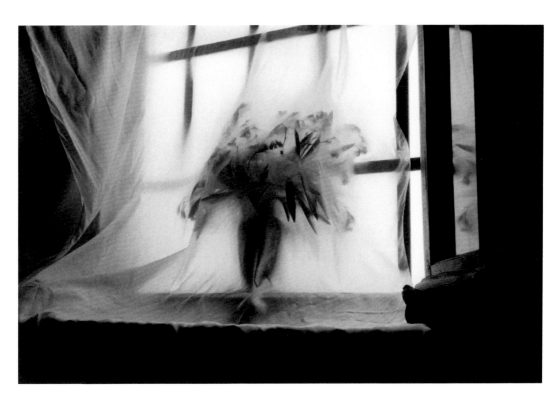

The sacristy

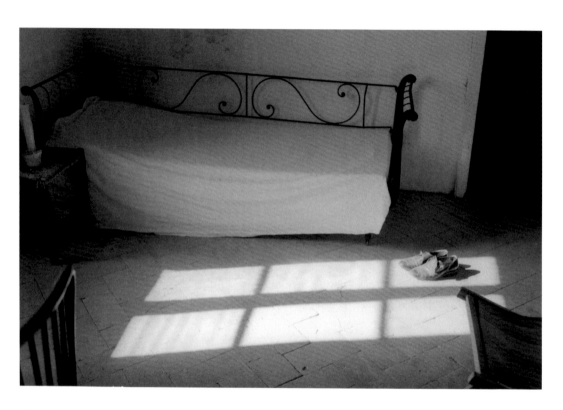

The departure

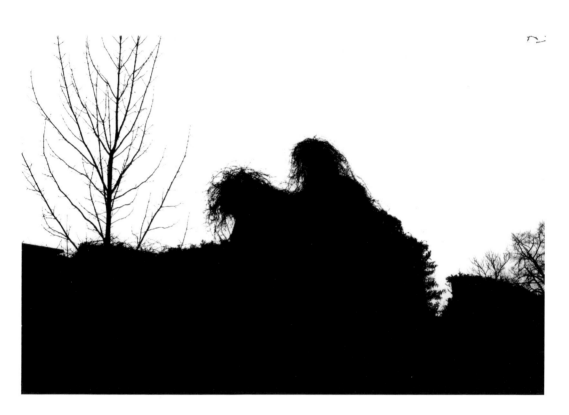

Bagheria

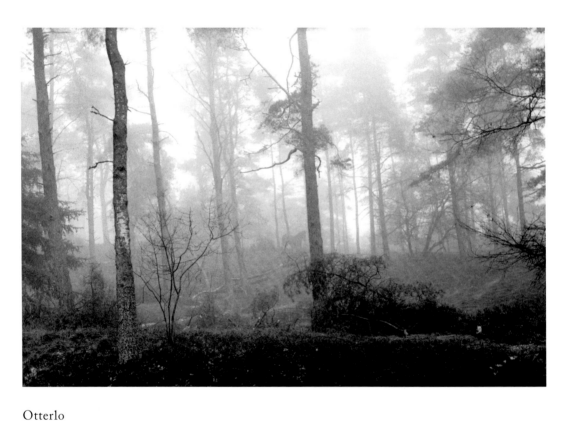

Otterlo

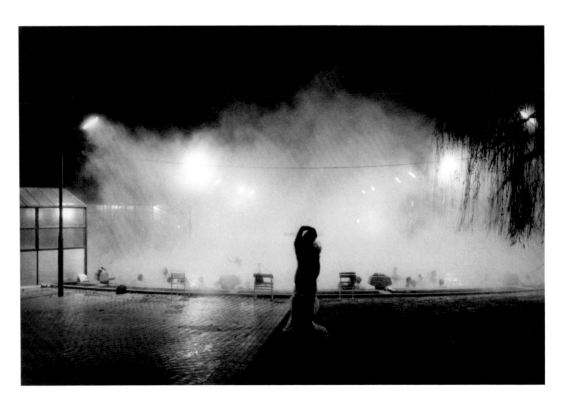

Budapest

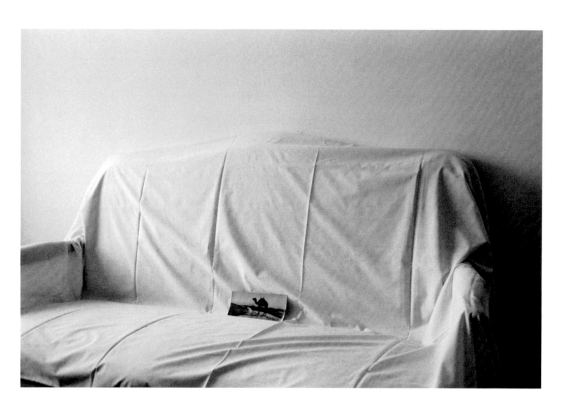

The dream of the desert

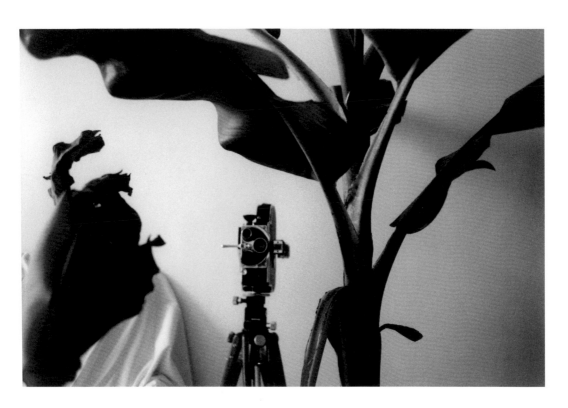

The dream of cinema

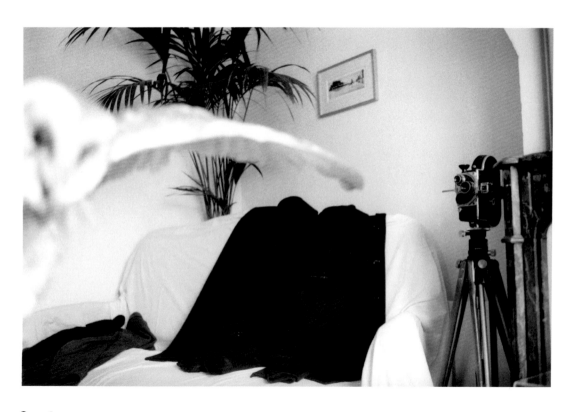

Interior

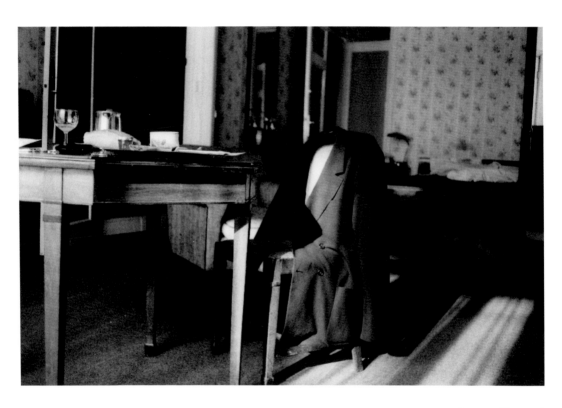

Cannes Festival

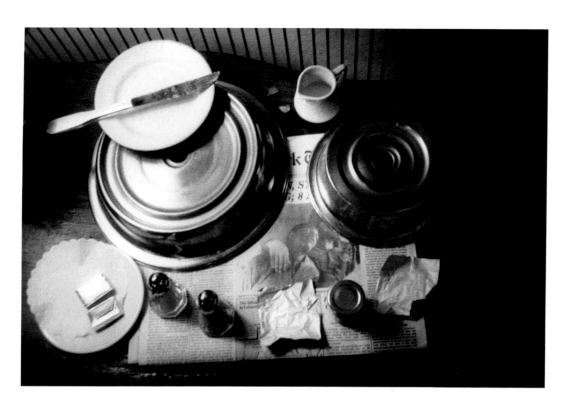

New York

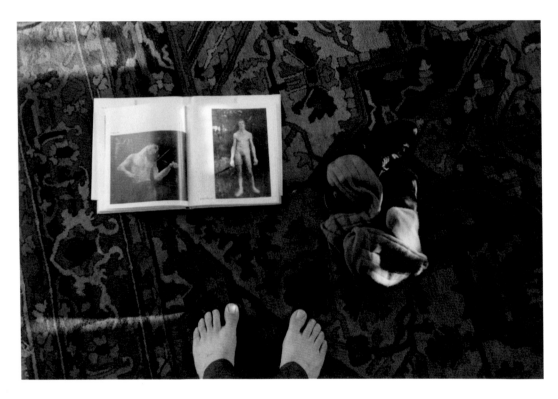

Paintings

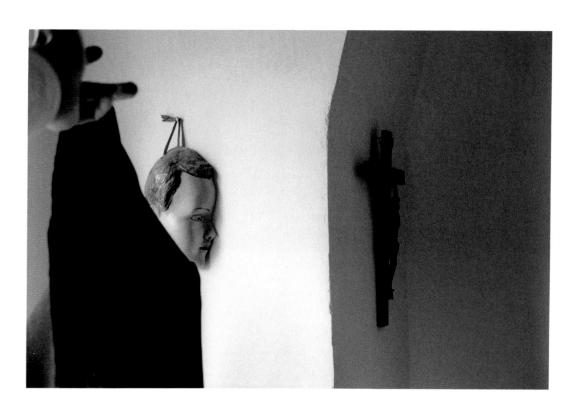

The puppeteer

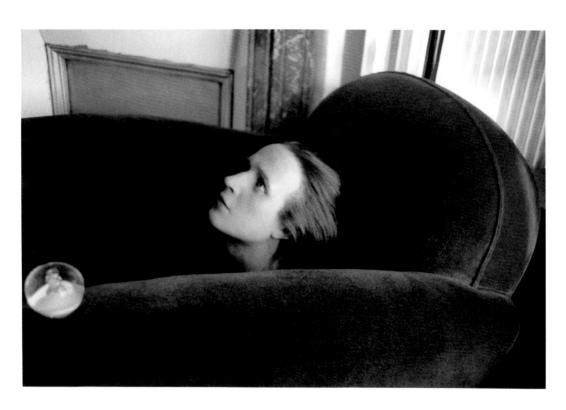

Joan of Arc

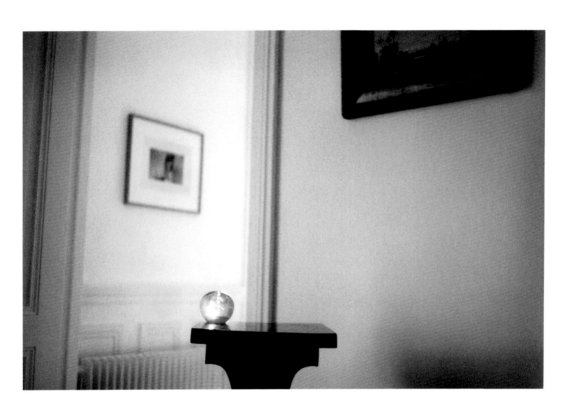

Yvonne's ball

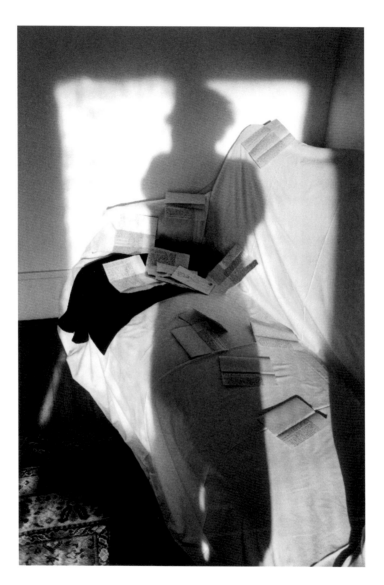

Mathieu's letters

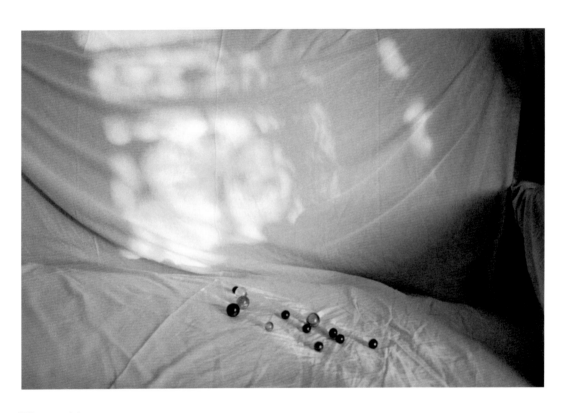

The marbles

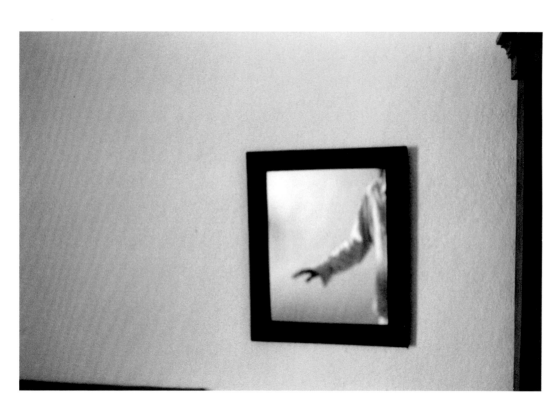

The blind man's hand

I first discovered the original French edition of *The Only Face* a couple years ago, when I ordered it on a whim. I remember getting the book in the mail and instantly being taken by its format and simplicity: a small softcover in the standard style of Les Éditions de Minuit, the storied French publisher run for many years by Jérôme Lindon, father of Guibert's good friend Mathieu Lindon. Unlike most other Minuit titles, *The Only Face* consisted mainly of photos. It was originally conceived as an exhibition catalogue for Guibert's solo show at Galerie Agathe Gaillard in Paris, but as I looked at it, over and over again, I realized it was so much more. As the text on the original back cover asks, "A book with figures and places, isn't that a novel?"

My Guibert obsession had begun shortly before, and I was looking into publishing his photo-novel *Suzanne and Louise* in English. Over the course of a year, though, I kept on returning to *The Only Face* as well. What I loved most was how it did all the heavy lifting with such economy of means. As a photographer and bookmaker myself, on a philosophical level, I found that inspiring. I also loved the way the book mixed different types of pictures — portraits of people from Guibert's life (family, friends, lovers), still lifes of their belongings and his, and views of places he had visited — all paired in spreads and sequenced like a poem. I had two simultaneous impulses: one was to look at the book for pleasure, and the other was to dissect it in order to understand its energies and see how it worked.

On a beach in Greece I read his three-page introduction for the first time, and it changed how I looked at the rest of the book. I also realized that this piece of writing was his treatise on photography — his feelings, confident and ahead of their time in 1984, about what photography meant to him and how it differed from his writing. In Mathieu Lindon's book *Hervelino*, he tells a fantastic story about *East Berlin*, a photo Guibert shot on an outing they took together in 1982. Later, after reading his friend's fictionalized account of their adventure, Lindon told Michel Foucault, "It was all wrong, it hadn't happened like that." Foucault replied, about Guibert, "Only false things happen to him."

With photography, he may not have had the same freedoms, but I don't think he was any less of a storyteller. This book is a testament to how good he actually was, as an image-maker but also as an editor. He understood that photography's real power came not just from pictures but from how they were used.

—Jordan Weitzman, Montreal, 2025

THE ONLY FACE
By Hervé Guibert

The photos in this book were taken between 1977 and 1984.

Originally published by Les Éditions de Minuit, 1984 on the occasion of an exhibition at Galerie Agathe Gaillard in Paris, September 26 - November 3, 1984. The prints were made by Didier Léger of Laboratoire Brégand.

This edition published by Magic Hour Press, 2025

Edited and designed by Jordan Weitzman
Cover by Marc Hundley
Translated by Christine Pichini
Prepress and duotones by Heyward Hart / Technikal Support

Images and text © Les Éditions de Minuit, 1984
Publisher's note © Jordan Weitzman, 2025
This edition © Magic Hour Press, 2025

The publisher would like to thank Georges Borchardt, Pauline Cochran, Charity Coleman Moyra Davey, Jason Fulford, Craig Garrett, Christine Guibert, Josh Lawson, Françoise Morin, Francis Schichtel, Thomas Simonnet

Printed in Italy by EBS

Distributed by
ARTBOOK/DAP
75 Broad Street, Suite 630
New York, NY 10004
Artbook.com

Paperback edition ISBN 978-1-7389013-5-7
Special casebound edition ISBN 978-1-7389013-8-8

www.magichour.press